Introduction

Coal mining records go back to the middle of the nineteenth century.[1] In the decade 1853–62 the average annual tonnage produced was in the region of 72 million. The first record of deep coal mines, for the decade 1893–1902, records 3,236 mines producing 207 million tonnes. Throughout the twentieth century, until 1958, output from the country's deep mines exceeded 200 million tonnes in virtually every year. The decline set in from 1964, with the tonnages steadily dropping year on year from 190 million to zero (4 million from opencast mining) in 2016. Just four deep mines and nine open-cast mines remained in operation in 2019. Consequently employment in the mining industry fell from 1.1 million in 1913 to around a thousand in 2019.

One of the principal uses of coal was to generate electricity to light and power the nation's industry. As electricity became more widely used throughout Britain's towns and cities a number of municipal boroughs built their own power stations. In the early years these were inevitably fed by coal, of which the UK had a plentiful supply. What is now known as the National Grid was first developed in the 1930s following the Electricity (Supply) Act of 1926, whereby some of the most efficient stations were linked together by, mainly, overhead power lines. The grid was nationalised in 1947 when the British Electricity Authority was created; it was privatised in 1990.

In the 1960s and early 1970s the government embarked on a programme of constructing new larger power stations to supply the grid and which had a far greater capacity to generate electricity than the myriad of smaller stations. The majority of these new stations were constructed with direct rail-connected on-site coal handling facilities and thus was born the Merry-Go-Round or MGR coal train. A new design of MGR coal hopper (to replace the hitherto used small mineral wagons) was developed to transport the coal in dedicated trains.

Following the production of two prototype wagons at Darlington in 1964, the vast majority of the 11,162 fleet, comprising seven variations, were built at Shildon, with the last being turned out in 1982. They were designed to carry 32 tonnes of pulverised coal and were normally seen in fixed length consists of between twenty-nine and thirty-seven wagons, depending on the motive power classification of the type of locomotive used. Loaded trains in transit were limited to a maximum speed of 45 miles per hour (55/60mph with hooded wagons) whilst empty consists could travel at 60 miles per hour. The system was first trialled at West Burton Power Station in Nottinghamshire but the first station to receive coal in MGR wagons on a regular basis was Cockenzie in 1966. With such a large fleet of dedicated wagons it was essential to have maintenance facilities to deal with them. These included specialised centres at Barry, Burton-upon-Trent, Coalville, Knottingley, Millerhill, Motherwell, Maindy (Radyr), Toton and Worksop.

Locomotives used to haul the trains have varied over the years. Initially locomotives of classes 20, 26, 37, 47, 76 and 81 were mainly employed. Some of these were fitted with low-ratio gears to enable them to travel at very low speeds whilst loading and discharging. A small number of Class 26s were confined to operation in Scotland whilst, although they were widely used in other areas, the Class 37 was almost exclusively the preferred option in the Welsh Valleys for

more than three decades. Initially Yorkshire coal was hauled by a dedicated fleet of Class 47/3s (this sub-class was fitted with slow-speed running gear) and the distinctive Class 76s, which were used over the Woodhead route and maintained at Reddish in Manchester. In the late 1970s the Class 56 became the dominant type of motive power and largely eclipsed the Class 37s and 47s in the Midlands, North East and Yorkshire. Next to make an appearance were the Class 58s, which were initially restricted to hauling MGR coal trains, mainly in the Midlands. These were followed by the introduction of the Class 60 and, finally, following privatisation of the railways, the Class 66 and to a much lesser extent the Class 70. The Class 20s had clung on in pockets in Lancashire, the Midlands and Scotland until the early 1990s. Also National Power operated its own fleet of six Class 59s in the Aire Valley for a period in the 1990s.

There was a number of motive power depots that were charged with maintaining locomotives engaged on coal transportation duties. The large 1960s-built diesel depots at Cardiff Canton, Edinburgh Haymarket, Gateshead, Glasgow Eastfield, Glasgow Polmadie, Immingham, Newport Ebbw Junction, Toton, Sheffield Tinsley and Swansea Landore were responsible for the heavy maintenance of the cross-section of motive power types. New purpose-built depots were established at Blyth Cambois (1968) in Northumberland, Knottingley (1967) in Yorkshire and Shirebrook (1965) in Derbyshire. A number of other former steam sheds were adapted for use by modern traction. These included the depots at Ayr, Colwick, Doncaster Carr, Kirkby-in-Ashfield, Mexborough, Nottingham, Saltley, Staveley Barrow Hill, Sunderland South Dock, Westhouses, Wigan Springs Branch and Thornton in Fife. In addition locomotives were outstationed at a number of sidings or yards, which included amongst their number Aberbeeg, Aberdare, Bescot, Cambus (Alloa), Carlisle Kingmoor, Coalville Mantle Lane, Crewe Basford Hall, Guide Bridge, Healey Mills, Millerhill, Pontypool Road, Radyr, Severn Tunnel Junction, Swansea East Dock, Wath-upon-Dearne, Tondu, Tyne Yard and Worksop.

Following privatisation GB Railfreight (GBRf) established a new maintenance depot for its freight locomotives at Peterborough (1999) whilst Freightliner opened new maintenance depots at Leeds Midland Road (2003) and Crewe Basford Hall (2016). As the power stations were closed down throughout the first two decades of the twenty-first century the majority of the depots were also closed leaving just a handful still functioning in 2021, one of which was Toton, which was responsible for the whole of the DB Schenker fleet of Class 66s. With the introduction of the latter from 1999 onwards a new design of larger capacity wagons soon followed. First introduced in 2001, these bogie wagons were built by Thrall UK at their York Works and measured 19.1 metres in length with a much larger carrying capacity of 74.5 tonnes. In 2020 they could be seen on the rail network in a variety of company liveries.

Coal has now been transported in MGR wagons for over fifty years with a network of distribution patterns set up across the UK to convey the fossil fuel from the distribution centres/ mines/ports to the power stations/steelworks. By 1970 there were around twenty rail-served coal-fired power stations using the MGR principal feeding the national grid.

Each of these power stations received coal by a network of MGR trains. For example Drakelow C in Derbyshire was initially supplied by as many as ten local collieries. Coal would first be transported to Toton Marshling Yard, which acted as a distribution centre before making its final journey to the power station. Similar distribution centres were located at Bescot Yard (West Midlands), Falkland Yard (Ayrshire), Healey Mills (Yorkshire), South Milford Sidings (Yorkshire), Staveley Barrow Hill, Thornton Yard (Fife), Tyne Yard, Warrington Arpley, Wath-upon-Dearne (Yorkshire) and Worksop Sidings. Not all the stations were fed by their local mine network. For instance, in the early days of operation, Fiddlers Ferry received its coal from both Point of Ayr (North Wales) and Yorkshire, with the latter travelling by the Woodhead route until its closure in 1981. Similarly, Didcot A was principally supplied by

MGR COAL TRAINS

MIKE RHODES

AMBERLEY

First published 2023

Amberley Publishing
The Hill, Stroud
Gloucestershire, GL5 4EP

www.amberley-books.com

Copyright © Mike Rhodes, 2023

The right of Mike Rhodes to be identified as
the Author of this work has been asserted in
accordance with the Copyrights, Designs and
Patents Act 1988.

ISBN 978 1 3981 0888 2 (print)
ISBN 978 1 3981 0889 9 (ebook)

British Library Cataloguing in Publication Data.
A catalogue record for this book is available from
the British Library.

Origination by Amberley Publishing.
Printed in the UK.

Power Station	Location	Years Active	Coal Source (guide only)[2]
Aberthaw B	Glamorgan	1971–2020	South Wales Valleys/Ayrshire; Avonmouth/Cardiff
Blyth B	Northumberland	1962–2001	Durham/Northumberland/Yorkshire
Cockenzie	East Lothian	1967–2013	Ayrshire/Fife/Lanarkshire/Lothians; Hunterston/Leith
Cottam	Nottinghamshire	1968–2019	Ayrshire/Nottinghamshire/Warwickshire/Yorkshire; Blyth/Hunterston/Immingham
Didcot A	Oxfordshire	1968–2013	Derbyshire/Nottinghamshire/Leicestershire/Warwickshire; Avonmouth/Portbury
Drakelow C	Derbyshire	1964–2003	Derbyshire/Nottinghamshire
Drax[3]	Yorkshire	1974–	Ayrshire/Northumberland/Yorkshire; Blyth/Hunterston/Immingham/Liverpool/Port of Tyne
Eggborough	Yorkshire	1967–2018	Durham/Northumberland/Yorkshire; Immingham/Port of Tyne
Ferrybridge C	Yorkshire	1966–2016	Yorkshire; Immingham/Port of Tyne
Fiddlers Ferry	Cheshire	1971–2020	Point of Ayr/Staffordshire/Yorkshire; Avonmouth/Hunterston/Liverpool/Portbury
High Marnham	Nottinghamshire	1959–2003	Nottinghamshire/Yorkshire
Ironbridge B	Shropshire	1969–2015	Derbyshire/Staffordshire/Warwickshire; Immingham/Liverpool/Portbury
Longannet	Fife	1970–2016	Ayrshire/Fife/Lanarkshire; Hunterston
Lynemouth[3]	Northumberland	1972–2015[4]	Northumberland; Blyth/Port of Tyne
Ratcliffe-on-Soar	Nottinghamshire	1968–	Ayrshire/Lanarkshire/Leicestershire/Nottinghamshire/ Yorkshire; Avonmouth/Hunterston/ Immingham/ Liverpool
Rugeley B	Staffordshire	1970–2016	Nottinghamshire/Staffordshire/Warwickshire; Avonmouth/Hull/Hunterston/Immingham/Portbury
Uskmouth B[3]	Monmouthshire	1959–2014[4]	South Wales Valleys; Avonmouth
West Burton A	Nottinghamshire	1967–	Nottinghamshire/Yorkshire; Blyth/Hunterston/Immingham
Willington B	Derbyshire	1962–1999	Derbyshire/Leicestershire/Nottinghamshire

[3] converted to burn biomass fuel
[4] ceased burning coal

the Nottinghamshire coal fields until their closure provoked a change to receive coal from South Wales and Avonmouth/Portbury. The latter received imported coal from Australia and South Africa.

In addition coal was also imported through Immingham and Hull docks, which came from a variety of countries including Columbia, Poland, Russia and the United States. Imported coal was also received through the Hunterston Terminal in Ayrshire, Liverpool's Gladstone Dock and to a lesser extent the Ports of Blyth/Tyne and Barry/Cardiff/Leith Docks. As the remaining power stations turned to the use of biomass (wood pellets) for fuel, these were imported through the Ports of Hull, Immingham, Liverpool and Tyne.

However, following the 2008 EU Ambient Air Quality Directive, the government established a programme to decommission all the remaining coal-fired power stations and since 2016 this has been rigorously implemented, with only three coal-powered stations remaining in use by the middle of 2021. However, by then the world was somewhat of a different place and reduction in the carbon footprint was very high on the agenda of world climate organisations. King coal's days as a heating fuel had become severely numbered. This book features a panorama of a wide variety of coal trains on the move between distribution centres and power stations across the United Kingdom. Also included are shipments of coal to the steelworks at Scunthorpe and in South Wales and examples of the movement of the fossil fuel to coal concentration depots for light industrial and domestic use.

Mike Rhodes

Source
[1] Department for Business, Energy & Industrial Strategy
[2] *Coal by Rail* – A Paper by Carl Brewer, University of Birmingham, 2012 (expanded)

Class 8F 2-8-0 No. 48476 is seen at Hoghton Foot Crossing (between Preston and Blackburn) on 24 April 1968 with a loaded rake of 16T mineral wagons. The train is 8P11 working from Parkside Colliery, near Newton-le-Willows, to Whitebirk (Great Harwood Junction Sidings). The coal would then have been tripped to Whitebirk Power Station. Parkside closed in 1993 whilst the power station closed in 1976. This is how it used to be for at least four decades before the advent of the MGR trains.

Despite the Rail Distribution sector decals on its side, Brush Type 4 No. 47211 (originally No. D1861 and new in August 1965) was photographed at Sankey on the approach to Warrington with an empty rake of MGRs heading back from Fiddlers Ferry PS to Yorkshire on 19 February 1992. It would appear that a few of the wagons have failed to discharge their load. No. 47211 was scrapped at Eastleigh in July 2003.

Bickershaw Colliery near Wigan also supplied coal to Fiddlers Ferry. Class 20s, based at Springs Branch MPD, were the usual motive power for a number of years. Having come south along the WCML, 1960s veteran Class 20s Nos 20168 and 20128 are seen making a double reversal at Warrington Arpley Low Level on 19 July 1989. Bickershaw closed in March 1992. Both Class 20s were still extant in 2021.

Class 20s Nos 20168 and 20059 are seen passing the site of Warrington Dallam steam shed on 26 May 1992 with a train of empty MGR wagons from Fiddlers Ferry to Bickershaw Colliery on 26 May 1992. Although the colliery had closed a few weeks earlier, the coal stocks were still being shipped out. The shed had closed in October 1967.

Above and right: Another view recorded at Sankey on the outskirts of Warrington, again on 19 February 1992, sees Class 60 No. 60076 *Suilven* with another rake of discharged MGRs from Fiddlers Ferry to Yorkshire. Carrying Trainload Coal livery, No. 60076 had only entered service three months earlier. Introduced to service in 1990, 100 of the Type 5 locomotives were built at Brush Engineering in Loughborough. Moments earlier Class 20s Nos 20094 and 20059 had passed heading for Fiddlers Ferry with the Unilever Soap Works in the background.

Class 47 No. 47441 is seen at Winwick, just north of Warrington, on 23 July 1990 with a short train of empty MGR wagons, possibly heading for Arpley Sidings. No. 47441 was delivered new as No. D1557, in February 1964, to Sheffield Darnall MPD. At the time this picture was recorded it was working off Crewe diesel depot and was a somewhat unusual choice for a freight train.

Freightliner Class 66 No. 66607 is seen making the reversing manoeuvre at Warrington Arpley on 5 June 2008. Having arrived from the north, most probably from Hunterston, it would then have continued west to Fiddlers Ferry. Arpley Junction signal box was opened in 1918 and was still functioning more than a century later.

Two northbound trains of Staffordshire coal are seen heading north through Crewe station bound for Fiddlers Ferry. *Above:* Class 20s Nos 20182 and 20175 were recorded on 15 September 1990. Celebrity Class 86 No. 86401 *Northampton Town* can just be glimpsed on the far right. *Below:* Class 56 No. 56019, in railfreight red solebar grey livery, is seen powering through the centre road on 19 September 1992 with another well-loaded train of coal bound for the Cheshire Power Station. A Class 153 DMU (seen in the distance) has just departed from the bay platform bound for Shrewsbury and possibly beyond to either Cardiff or Swansea. No. 56019 was withdrawn in October 2003 and scrapped by Harry Needle at Immingham MPD the following month.

The Class 66s were introduced in 1998 and the first 250 built were ordered by the English, Welsh & Scottish Railway (EWS), which was later owned by first DB Schenker and then DB Cargo UK. All 250 were based at Toton MPD for maintenance, including those members of the class that moved to Europe. Class 66 No. 66239 pauses at Crewe with a train of imported coal from the Hunterston Terminal in Ayrshire to Rugeley B Power Station on 30 September 2005.

On a murky day in July 1991, Class 60 No. 60003 *Christopher Wren* was photographed passing through Ditton station with a rake of empty MGR wagons, whilst on a driver training run from Garston to Crewe. This was a precursor to operating coal trains from Liverpool Docks. No. 60003 was one of a number of the class owned by DB Cargo UK and stored out of use at Toton MPD in 2020.

Fiddlers Ferry Power Station also received coal from Point of Ayr Colliery in North Wales (near Prestatyn). For a spell these were hauled by pairs of Class 20s, which were again based at Springs Branch MPD. *Right:* Class 20s Nos 20135 and 20084 have paused at Chester with a rake of empty refurbished MGR wagons on 19 July 1989. *Below:* Class 20s Nos 20090 and 20013 are seen with another empty consist alongside Chester Racecourse on 21 September 1991. Once a very busy line, four tracks prevailed along most of the North Wales' coastal route to cater for the substantial holiday traffic. The two lines on the left were taken up in the mid-1980s. Point of Ayr closed in 1996.

Class 20s Nos 20143 and 20214 are seen at Mold Junction on 11 August 1991 with a load of coal from Point of Ayr to Fiddlers Ferry Power Station. They are passing the site of Mold Junction steam shed (on the left), which closed on 18 April 1966. The sidings on the right were once part of a slate depot whilst a station, with the uncharacteristic name of Saltney Ferry, also used to exist at this location. Opened in June 1891 by the London & North Western Railway, it closed to passengers on 30 April 1962.

Class 60 No. 60006 *Great Gable* is seen at Carlisle on 30 August 1990 on a driver training run from Crewe. It has a short rake of HEA coal wagons in tow. The HEA was built at Shildon Wagon Works and first introduced in 1975. The discharge doors were manually operated and their original intended use was for the conveyance of domestic coal to concentration depots. Following the decline of the depots many were put to other uses such as for the transportation of rock salt and scrap metal.

There was a significant amount of coal traffic passing through Carlisle in the first decade of the twentieth century, hauled by both EWS and Freightliner. The principal flows were from the Hunterston Terminal in Ayrshire to Cottam, Drax, Fiddlers Ferry, Ratcliffe and Rugeley power stations. *Above:* No. 66604 is seen taking the route via the Settle & Carlisle line on 18 March 2008 and is possibly bound for Drax. The Class 66/6s were fitted with reduced gearing to assist with heavier trains. *Below:* Seen on 23 June 2009, DB Schenker Class 66 No. 66095 is taking the route via the West Coast Main Line and will be bound for either Fiddlers Ferry or Rugeley B Power Station. By the time of these photographs the short-wheelbase MGR wagon would all but have been eliminated from the railway scene, with the last being taken out of service in 2010. The replacement bogie wagons were built by Thrall UK of York from 2001 to 2004 and had a payload capacity of 74.5 tonnes.

Class 66 No. 66419 was one of a batch of ten leased by DRS (Direct Rail Services) in 2006 for use on intermodal trains on the West Coast Main Line (WCML). In 2011 the entire batch passed to Freightliner and was initially based at Leeds Midland Road MPD. No. 66419 is seen passing through Carlisle Citadel station on 27 June 2012 with a train of empties bound for Scotland.

The Settle & Carlisle line has a somewhat recent chequered history. It was opened by the Midland Railway in August 1875, initially for goods traffic. It was threatened with closure in the 1980s but a reprieve was followed by investment in the line and a resurgence of traffic. Freight traffic, which had been absent for more than three decades, also returned to the route. EWS Class 66 No. 66129 was recorded at Appleby on 19 March 2003 with a load of coal from Ayrshire to Drax. The semaphore signals were still in use in 2021.

Somewhat remote and desolate, the Settle & Carlisle line is nevertheless renowned for its stunning scenery, which is aptly portrayed in these two studies recorded at Ais Gill on 25 January 2007. This is the summit of the line and is 1,169 feet above sea level. *Above:* EWS Class 66 No. 66025 is seen in the shadow of Wild Boar Fell with a southbound train of coal bound for Yorkshire. *Below:* Freightliner Class 66 No. 66563 is seen travelling in the opposite direction with a train of empties bound for Hunterston.

EWS Class 66 No. 66125 is seen crossing Dandry Mire Viaduct at Garsdale on 19 March 2003 with a rake of conventional empty MGR wagons. The twelve-arch Grade II listed stone viaduct took six years to build from 1869 to 1875. Mount Zion Chapel (Hawes Junction Methodist Chapel), dedicated on 1 May 1876, can be seen in the foreground.

EWS Class 66 No. 66178 is seen from the B6255 at Ribblehead on 10 May 2006 crossing the magnificent twenty-four-arch stone viaduct with a loaded train of coal bound for Yorkshire. The Pennine Hills are prominent in the background.

Freightliner Class 66 No. 66506 *Crewe Regeneration* was photographed heading south through Settle station on 26 August 2005 with a trainload of imported coal from Hunterston and bound for one of the Aire Valley power stations. The immaculately kept station is a Grade II listed building and is tended to by the Friends of the Settle–Carlisle Line. The town of Settle had a population of 2,400 in 2020 and is regarded as the start of the 72-mile line through North Yorkshire and Cumbria to Carlisle.

Hellifield is situated at the junctions of the lines from Clitheroe and Skipton and in steam days it boasted its own engine shed (which closed in June 1963). The shed was later used to store steam locomotives that had been saved for preservation. On 4 May 2006 Class 66 No. 66127 has paused briefly on its journey to Yorkshire. By 2006 trains of HAA wagons over this route were in the minority.

The original Skipton station was opened by the Leeds and Bradford Extension Railway in September 1847, and was later absorbed by the Midland Railway. The line through to Settle and Carlisle was opened in April 1876. Class 66 No. 66129 is seen heading north at Skipton on 14 September 2007 with a train of empty coal wagons. The station is now a Grade II listed building.

Padiham Power Station in East Lancashire was one of the many parochial stations that were established following the Electricity Supply Act of 1926. It continued to produce electricity for the National Grid until its closure in 1993. Although it was rail connected, it had no Merry-Go-Round facilities and coal was delivered in conventional wagons. It was latterly supplied by the Maryport Opencast Mine in Cumbria and Class 60 No. 60060 *James Watt* is seen crossing the viaduct in the centre of Accrington with the return empties on Saturday 10 October 1992.

The Deepdale Coal Concentration Depot in Preston was one of the last in the UK to receive coal by rail. Class 37 No. 37898 was photographed on the branch (originally to Longridge) from the bridge at Leighton Street on 26 May 1994 with the return train of empty HEA wagons to South Wales. This was the last year in which the train ran.

Class 66 No. 66026 is seen at Bee Lane, just south of Preston, on 2 September 2002 with a returning train from Fiddlers Ferry to Ayrshire. The line diverging to the right leads to Ormskirk and Blackburn/Yorkshire, with the latter crossing over the main line by the bridge in the far distance.

These two pictures, taken under the impressive station roof at Preston, both feature northbound empty coal trains passing through platform 3 (previously platform 5), but fifteen years apart. However, there is one distinctive difference – by the time the lower picture was recorded the roof, which dates from the mid-1870s, had benefitted from a painstaking cleaning and maintenance programme. *Above:* Class 56s have never been a common sight at Preston but on 1 April 1995 No. 56086 was rostered for a train of empties from Fiddlers Ferry to Ayrshire. *Below:* Class 66 No. 66175 is seen on a similar working from Fiddlers Ferry or Rugeley on 21 June 2010. Preston station is another Grade II listed structure.

Above: Freightliner Class 66 No. 66564 is seen with a northbound MGR train passing through platform 4 at Preston station on 15 December 2008. This is most likely a working from Fiddlers Ferry to Hunterston Terminal. The original station was opened by the North Union Railway in 1838. It was extended in 1850 and rebuilt in the mid-1870s and further extended between 1899 and 1903 with thirteen platforms at its maximum size. The present layout dates from the early 1970s when the line was electrified. *Below:* Class 66 No. 66559 is seen on the centre road at Lancaster with another northbound train on 6 February 2014. One of TransPennine's Class 350/4s waits to depart with a train bound for Manchester Airport.

The Woodhead line between Manchester and Sheffield was built by the Sheffield, Ashton-under-Lyne & Manchester Railway and opened in 1845. Electrification of the route, which included the provision of two new tunnels under the Woodhead Pass, was finally completed in 1955. The electrified route was primarily worked by fifty-eight Class EM1 (later 76) and seven EM2 (77) locomotives with the latter designed for passenger work. Whilst the through passenger service was withdrawn on 5 January 1970, the line remained open for freight until 18 July 1981. *Above:* Class 76s Nos 76006 and 76024 are seen approaching Hadfield on 26 March 1981 with a train of loaded MGR wagons from Wath to Fiddlers Ferry. *Below:* Several years earlier, on 29 December 1976, Class 76s Nos 76015 and 76033 were similarly employed. They are passing Class 506 'Hadfield' unit No. 05. One of a class of eight EMUs, they worked the local service from Manchester Piccadilly for thirty years, being withdrawn in 1984.

An unidentified pair of Class 76s are seen crossing Dinting Viaduct on 25 March 1981 with a train of return empties from Fiddlers Ferry. The original bridge, which crosses the Glossop Brook Valley, was opened in 1844; it was strengthened with the construction of additional brick piers in 1918–20.

During the 1970s and early 1980s the coal trains from Yorkshire to Fiddlers Ferry used to take a convoluted route around Manchester. Routed via Woodhead (until closure) or Standedge, they would diverge at Guide Bridge and take the line through Denton and Reddish to Stockport before diverging west at Edgeley Junction and following the old London & North Western route through Lymm and Latchford to Warrington Arpley. However, the last section was closed in July 1985 and the trains were henceforth routed via Manchester Victoria. Class 56 No. 56121 is seen crossing the impressive viaduct that dominates the centre of Stockport on 8 March 1984 with a train bound for Fiddlers Ferry.

In days gone by many a steam-hauled freight train has struggled to ascend the 1 in 47/1 in 59 gradient leading east out of Manchester Victoria station towards Miles Platting. So much so that the assistance of a banking engine was often required. Fortunately the loaded coal trains from Healey Mills to Fiddlers Ferry Power Station, which were rerouted this way from July 1985, were travelling down grade. *Above:* On 8 April 1992 Class 56 No. 56068 was photographed from the east end of the station hauling a train of Yorkshire coal bound for Fiddlers Ferry. *Below:* Another load of coal is seen passing through the centre road on 22 October 1991 behind No. 56111. The photographer's vantage point is on platform 11, which once connected through to platform 3 on the adjacent Exchange station (closed on 5 May 1969) and at one time was claimed to be the longest station platform in Europe, at 2,238 feet in length. Victoria was upgraded and rationalised between 2013 and 2015, thereby losing its Victorian character in the process.

One of the shortest coal hauls in the UK was from Monktonhall Colliery (closed in 1997), adjacent to Millerhill Yard, to Cockenzie Power Station (closed in 2013). Class 26 No. 26007, which is seen reversing into Millerhill Yard in this mid-1980s view, was one of seven of the type fitted with slow speed gear for use on MGR coal trains in Scotland. Originally numbered D5300, No. 26007 was withdrawn from Eastfield MPD in October 1993 and is now preserved. (Steve Wakefield)

Class 37 No. 37691 is seen heading south at Dalmeny on 2 July 1992 with a train of empty MGRs from Longannet Power Station. Longannet received coal from the four principal areas of coal mining in Scotland, which included Ayrshire, Fife and Lanarkshire. However, this train is possibly destined for Blindwells Opencast Mine in East Lothian, which was one of the last functioning mines in the area.

On 2 July 1992 the conveyance of coal from Edinburgh's Lothian pits (Monktonhall and Blindwells) to Longannet Power Station was firmly in the hands of Class 56s. *Above:* No. 56090 is seen near South Gyle on the outskirts of the city with a twenty-three-wagon rake of loaded MGRs. *Below:* A little further west, at Dalmeny, and No. 56075 is seen with a shorter train of loaded hooded-MGR wagons. The canopied wagons were coded HBA and HCA under TOPS (Total Operations Processing System) and were permitted to travel at a maximum speed of 60 mph when loaded. It is likely that both trains had originated at Blindwells Opencast Mine and travelled from Millerhill via the cross-city suburban line, which joins the main line at Haymarket and avoids Edinburgh Waverley station. Blindwells was the last of the rail-connected Lothian mines to remain in production and closed in 2000.

On 2 July 1992 Metals Sector-designated Class 60 No. 60023 *The Cheviot* was engaged on crew training duties in the Edinburgh area. It is seen approaching Dalmeny with a working from Millerhill to Longannet. Earlier in the day it had also been noted at Curriehill with a trip to Ravenstruther. The line on the right leads to Linlithgow and Falkirk.

Class 56 No. 56092 has paused in Edinburgh Waverley station on 3 September 1996 with a train of HEA wagons. Besides their intended use for coal, as previously stated these wagons were also used to carry scrap metal and rock salt (for spreading on icy roads). No. 56092 was withdrawn three years later and cut up at Wigan Springs Branch in July 2001.

Class 66 No. 66105 is seen at Dunfermline Town station with a rake of empty MGR wagons from Longannet Power Station on 2 September 2005. It will continue a short distance further on before recessing for the engine to run round and head south towards the Forth Bridge with a final destination of possibly Hunterston.

In May 2008 the line from Stirling to Dunfermline via Alloa was reopened. This offered an alternative route for trains conveying coal from Hunterston to Longannet Power Station. On 9 May 2013 Class 66 No. 66047 was recorded at Stirling station with a train of empties from Longannet. The power station was closed in March 2016.

Sunderland South Dock shed was opened by the North Eastern Railway in 1857 and in the later years of steam it was well known for its allocation of J27s and Q6s. It closed to steam in September 1967 but remained in use as a diesel stabling point until April 1994. On 10 September 1989, Class 56s Nos 56113 and 56126 were amongst several of the type keeping Class 08 No. 08421 company.

One of Cambois' stable of Class 56s No. 56129 is seen rattling through Newcastle Central station on 26 April 1989 with an empty rake of wagons from Blyth Power Station. On the right the cantilever arch of the Tyne Bridge can just be glimpsed whilst on the left the twelfth-century castle keep looks down on the station proceedings.

Lynemouth Power Station continued to take coal from local mines until eventually the last ones closed and the power station had to turn to imports. These were still obtained locally, either through the Port of Blyth or the Port of Tyne. GB Railfreight (GBRf) Class 66 No. 66729 *Derby County* is seen passing through Newcastle Central station with a trainload from the latter on 18 November 2010.

One of Cambois' (closed in September 1994) twenty-two Class 56s, No, 56131, is seen heading south at Colton Junction (near York) on 24 June 1994. It is conveying coal from Northumberland to either Drax or Eggborough power stations. The train would often change engines at York (but not on this occasion) and as many as a hundred trains might run in a single week. No. 56131 *Ellington Colliery* (closed in 2005) was withdrawn in 2005 and cut up at Booth's of Rotherham two years later.

Loaded coal trains could be seen going both ways at Colton Junction as this northbound consist of Yorkshire coal, hauled by Class 56 No. 56090 on 24 June 1994, testifies. This load may be bound for Redcar Steelworks. Production at the works ceased in 2015.

A few miles north of South Milford lies the station of Church Fenton where the passenger train route to Leeds diverges to the west. Class 56 No. 56101 *Frank Hornby* is seen heading south, possibly to South Milford, with a train of North East coal on 11 July 1991. Church Fenton signal box, in the distance, was opened by the North Eastern Railway in 1904 and closed in April 2002 when control was passed to the York Integrated Electronic Control Centre (IECC).

On 25 August 2000 two-month-old Class 66 No. 66242 was photographed at Church Fenton with a train of empties heading back to the North East. No. 66242 was one of several EWS/DB Cargo Class 66s that were transferred across the channel to work freight trains in France. One of Yorkshire's three-car Class 158/9 Metro trains is waiting to depart with a train for York.

Still in rail blue, Class 56 No. 56003 was photographed drifting through Knottingley station on 27 March 1985 with empties from either Eggborough or Drax power stations. Knottingley station is situated on what was originally the Wakefield to Goole Railway, which opened in April 1848. It is now a terminal point for trains from Leeds, which reverse at Castleford.

Right and below: With the commissioning of three rail-served power stations in close proximity between 1966 and 1974 it made economic sense to provide a locomotive servicing depot in the same locality. Knottingley diesel depot was opened in 1967 and initially had an allocation of Class 47s for the local coal traffic. These were superseded by Class 56s during the 1980s and later joined by Class 58s, 59s and 60s in the following decade. The final type allocated there, before closure in March 2020, was the Class 66. The 59s were serviced at Ferrybridge before being acquired by EWS. Seen opposite are Class 56s Nos 56107/103/123 *Drax Power Station*, on 6 May 1989, whilst fourteen examples of the type can be counted in the picture below, which dates from 24 June 1989. MGR coal wagons were also repaired at the depot. Ferrybridge PS is in the background.

Seen the same day passing Knottingley depot with another rake of empty MGR wagons heading back to the North East is Class 56 No. 56118. The small shed on the left is where maintenance was carried out to the MGR wagons. A Class 141 Pacer unit is waiting in the turnback siding before drawing forward into the station to form a departure to Leeds.

Looking from the same overbridge at Knottingley, but in the opposite direction (west), Class 56 No. 56004 was photographed on 23 May 1997 with a load of coal for one of the two power stations situated down the line. Knottingley station can be seen in the distance. No. 56004 was withdrawn in June 2005 and cut up at C. F. Booth's yard in Rotherham a year later.

For more than three decades the yard at South Milford (in the distance) was a hive of activity for MGR trains with both empty and loaded rakes of wagons being stabled there as part of their journey to and from the mines and the power stations. On 11 July 1991 Class 56 No. 56069 has just departed with a load of coal whilst No. 56071 is bringing back another consist of empties.

During the 1980s and 1990s Burton Salmon tended to be a busy location with a stream of empty and loaded MGR trains passing at frequent intervals. Class 56 No. 56105 was in charge of a rake of empties from the Castleford direction on 17 May 1996. This would most likely have been returning from Ferrybridge Power Station (which had a south facing access line). Doncaster-built No. 56105 was still in use, with Colas Rail, in 2021.

Another empty coal train is seen at Burton Salmon on 17 May 1996 but this one is coming directly off the Aire Valley line and would be returning from either Drax or Eggborough. Seen here No. 56031 *Merehead* is painted in what was commonly referred to as 'Dutch Livery', which was usually applied to locomotives used for departmental/engineering duties. This was another Class 56 that was still in use in 2021, but with GB Railfreight.

Looking north at Burton Salmon from the same vantage point, this picture of Class 56 No. 56084, with a very generously loaded train which is creating a dust haze, was captured on 6 May 1993. The layout used to be very different at this location with a platform face adjacent to the two far tracks and a goods dock on the extreme right. Burton Salmon station was closed in 1959.

Three Trainload Freight Business sectors were created in 1994, namely Loadhaul, Mainline and Transrail. Newly outshopped in Loadhaul livery, Class 56 No. 56006 is seen drawing away from South Milford Sidings on 1 November 1994 with a loaded train of MGRs. These business sectors were short-lived as they were all acquired by EWS in February 1996. The locomotive is now preserved in its original rail blue livery.

Class 56 No. 56081 is seen approaching Gascoigne Wood Junction on 6 May 1993, where it will diverge into the Selby Drift Mine (since closed) to be filled with another load of coal. Although only thirty-five of the type were still extant in 2021, this was another of the class that survived the test of time and was also owned by GB Railfreight. The cylindrical tanks in the background are part of a biogas plant.

Above: This picture encapsulates the concept of the MGR coal train in its entirety. Class 58 No. 58016 is seen passing Knottingley MPD on 14 May 1997 with a rake of empties, where not only are the locomotives serviced but the wagons are also maintained on the same site. In the distance can be seen two of the three Aire Valley power stations, Eggborough and Drax *Below:* Class 56 No. 56088, now repainted in EWS livery, is seen heading east past Knottingley Depot on 2 September 1999 with a consist of empty MGR wagons. It was quite likely heading for nearby Kellingley Colliery, which remained in production until 2015. As in the above picture, several newly overhauled wagons can be seen in the foreground. Ferrybridge Power Station can also be seen on the extreme right.

When new forty-two of the Class 60s were dedicated to the coal sector as denoted on these two examples by the black diamonds on a yellow background. *Above:* No. 60047 *Robert Owen* is seen at Monk Fryston on 6 May 1993 with a return working from Fiddlers Ferry to South Milford. *Right:* Two months later No. 60058 *John Howard* was photographed at Burton Salmon with a loaded train for the Aire Valley. The locomotives were named after an eighteenth-century Welsh textile manufacturer and a twentieth-century civil engineer respectively. The sector markings were removed following the acquisition of the whole class by EWS.

This busy scene was recorded at Monk Fryston/South Milford on 9 July 1993. Class 58 No. 58048 *Coventry Colliery* is crossing cover to take the Castleford route with a loaded train of coal bound for Ferrybridge Power Station whilst two more Class 58s can be seen in the sidings in the distance. In order to access the south-facing branch at Ferrybridge the trains were routed via Castleford and Pontefract (of the sweet of the same name fame) Monkhill.

At first glance this appears to be an extremely long train but the rear section is actually another train disappearing into the distance. Class 60 No. 60029 *Ben Nevis* is seen at Monk Fryston on 18 June 1999 returning empty to South Milford with the standard consist of thirty-six wagons.

Following the privatisation of the electricity generating board in 1990 both Eggborough and Drax power stations came under the control of National Power. Coal had continued to be transported by the different rail companies but in February 1994 NP received the first of an eventual six Class 59s with the other five following in August 1995. Class 59 No. 59206 *Pride of Ferrybridge* was photographed passing Eggborough PS junction with empty coal hoppers from Drax to Gascoigne Wood on 14 May 1997.

National Power's Class 59s were built at General Motors' EMD factory in Ontario Canada and arrived in the UK through the Port of Hull. Following trials with No. 59201 hauling stone trains from Peak Forest they were put to work on the short-haul coal trains between the Selby Drift Mine at Gascoigne Wood and Ferrybridge and Drax power stations. Class 59s Nos 59205 *Vale of Evesham* and No. 59202 *Vale of White Horse* were about to cross when seen at Monk Fryston on 14 August 1997.

In April 1998 National Power sold their Class 59 locomotives to EWS for continued use on the Yorkshire coal trains. Class 59 No. 59206 *Pride of Ferrybridge* is seen again, now repainted into EWS colours, with a loaded train at Monk Fryston on 12 October 1999. Class 66 No. 66010 can be seen departing South Milford Sidings with empty MGR wagons that are bound for the Castleford route.

A view of Leeds Midland Road Depot, which was taken from Balm Road Bridge on Sunday 4 January 2009. Class 66 No. 66583 is stabled in Hunslet Sidings on the right whilst five former Direct Rail Services Class 66s can be seen in store alongside the depot. New in 2006, they were originally leased from Halifax Leasing and then Lloyds TSB General Leasing.

Freightliner established a new maintenance depot on the outskirts of Leeds in July 2003. Located on the line to Castleford and Knottingley, opposite Hunslet Sidings, it was ideally placed to provide motive power for the intense Aire Valley coal traffic and the nearby Stourton Freightliner Terminal. Class 70 and MGR wagon maintenance was also undertaken at the site. There are nine stabling roads with two undercover, which are equipped with pits to allow access to the undersides of the locomotives. *Above:* In this view, recorded on 3 January 2010, No. 66609 sits in front of one of the covered bays whilst No. 66601 *The Hope Valley* heads a long line of locos that includes one Class 70. Stourton Freightliner Terminal can just be seen beyond the bridge. *Below:* A view of the depot from the aforementioned bridge taken on 6 August 2008 with No. 66953 seen moving on shed. The seven Class 66/9 variants produced lower emissions but had a reduced fuel capacity.

Above and below: A total of 135 Class 56 locomotives were built and the vast majority were employed on coal trains in the Midlands, North East and Yorkshire. Whilst the first thirty were built in Romania the next eighty-five were built at Doncaster, with Crewe providing the final twenty. The first Class 56 built at Doncaster Works entered service from Toton MPD in May 1977 whilst No. 56050, seen above under construction on 1 October 1978, left the works at the end of the month. It was withdrawn in April 2004 and cut up at C. F. Booth's yard at Rotherham. No. 56070 is seen below in Doncaster Works on 5 November 1989 undergoing a heavy overhaul. It was also withdrawn in 2004 and cut up at Stockton.

Class 56 No. 56097 is seen at Thurnscoe on 24 June 1992 with what is probably a Ferrybridge to Goldthorpe Colliery empty MGR working. The colliery closed in 1994. This particular locomotive is now preserved at the Great Central Railway at Loughborough.

In the mid-1980s the South Yorkshire coal trains were mainly being worked by a mixture of Class 37s, 47s and 56s. Two of the former, Nos 37030 and 37010, were photographed powering through Mexborough station on 7 May 1985. The destination of this load may well have been Scunthorpe Steelworks. The classic footbridge, which is still there, is similar to the one featured in the picture at Worksop (see p. 57), except it has no canopy.

More variety at Mexborough recorded on 7 May 1985. *Above:* Class 47 No. 47197 was photographed heading west with a train of empties, possibly heading for nearby Silverwood Colliery. The mine stopped producing coal in 1994 but the last coal stocks were not removed until two years after closure. No. 47197 was delivered new to Crewe in June 1965 having also been built in the town's workshops. It gave over forty years of service and was withdrawn in February 2007. *Below:* Looking west towards the station, Class 56 No. 56010 is seen heading east with a loaded train, again which has mostly likely originated from Silverwood Colliery. Another train of MGRs can be seen disappearing into the distance. The Class 56 was withdrawn in February 2004 and cut up two months later.

Class 20s Nos 20118 and 20009 are seen rattling through Mexborough station on 7 May 1985 with an eastbound train of HEA coal wagons. No. 20009 was originally No. D8009 and first entered service on cross-London trip freights from Devons Row (Bow) MPD in October 1957; it was cut-up at MC Metals' Glasgow yard in November 1993. No. 20118 on the other hand was more fortunate and is preserved at the South Devon Railway.

In 1989 there were still a number of active coal mines in the Doncaster area that produced regular flows of coal. These included the pits at Askern, Bentley, Brodsworth, Harworth, Hatfield, Maltby, Markham Main and Rossington. Class 56 No. 56087 was photographed at Doncaster on 8 March with empty MGR wagons heading for one of the three collieries to the south of the town.

By 2009 only Hatfield and Maltby of the aforementioned mines were still producing coal. Class 66 No. 66020 is seen slowly approaching Doncaster station with a rake of bogie MGRs on 2 July 2009. No. 66020 was repainted into DB Cargo UK red livery in May 2017 and was still active from Toton MPD in 2021.

The freight operator Fastline was founded in 1994 and had a small pool of locomotives that comprised three Class 56s and six Class 66s. Amongst the coal flows operated were Daw Mill and Hatfield Collieries to Ratcliffe PS, Daw Mill to Cottam PS and Immingham to Ironbridge PS. One of the principal flows was from Hatfield to Ratcliffe, illustrated here by Class 66 No. 66304, which was photographed passing through Doncaster station on 28 July 2008. The company ceased trading in March 2010 with Nos 66301–5 passing to DRS.

Freightliner Class 66 No. 66561 was photographed heading south through Doncaster station on 2 April 2013. This is likely to be a load of imported coal from either Immingham or Hull and bound for either Cottam, Ratcliffe or Rugeley PS.

GB Railfreight undertook a contract to deliver coal from the North East, particularly the Port of Blyth, to both Cottam and West Burton power stations. After more than ten years taking coal to Cottam the flow ceased when the power station closed in September 2019. GBRf was established in 1999 and had amassed a fleet of ninety-one Class 66s by 2021. No. 66746 is seen at Doncaster on 23 July 2013, heading for one of the two aforementioned electricity-generating stations.

Barnetby station was a magnet for railway photographers for many years. It retained its vast array of semaphore signals until December 2015 and these, coupled with the intensity of freight traffic, made the location an attractive proposition for photographing trains. There was often a constant stream of coal trains, which originated at the Immingham Import Terminal, and would be bound for either Scunthorpe Steelworks or one of several distant power stations; these included Cottam, Drax, Eggborough, Ferrybridge, Ironbridge, Ratcliffe, Rugeley and West Burton. *Above:* Freightliner Class 66 No. 66514 is seen with an eastbound train of empties on 10 March 2007. *Below:* Similar No. 66519 is seen on the same day with a loaded train from Immingham. The vast array of signals was controlled by two signal boxes: Barnetby East, as seen below, and Wrawby Junction, which can be seen in the distance in the upper picture.

Looking towards Wrawby Junction, where there is a three-way split with lines to Lincoln, Gainsborough and Scunthorpe diverging, Class 56 No. 56102 *Scunthorpe Steel Centenary*, in Loadhaul livery, is seen at Barnetby on 14 August 1997 with a train of empty MGRs from Scunthorpe to Immingham. Plenty of semaphore signals to admire in this view.

A mile or so to the east of Barnetby lies the hamlet of Melton Ross where Class 56 No. 56035 was recorded heading towards Immingham on the frosty misty morning of 29 November 1994. A Class 158 on a service from Cleethorpes to Manchester can be seen receding into the distance. The line on the left was brought back into use a few years later due to the intensity of traffic on the route.

Another view at Melton Ross, but looking east from Bigby Road overbridge, sees Class 66 No. 66087 heading a train of imported coal from Immingham on 20 July 2006. The Class 66s were by and large the successors to the Class 56s on the coal trains on this route

A prominent landmark on the Lincolnshire line between Barnetby and Brocklesby is the Singleton Birch lime production works, which was first established in 1815. In this view, recorded on 31 March 1993, Class 56 No. 56104 is seen hauling a train of imported coal from Immingham Docks to Scunthorpe Steelworks.

Brocklesby station was opened by the Manchester, Sheffield & Lincolnshire Railway in 1848 and is where the freight line to Immingham diverges from the line to Grimsby and Cleethorpes. The route was later absorbed by the Great Central Railway. *Right:* On 31 March 1993 Class 56 No. 56106 is seen sweeping round the curve from the Immingham branch with a train of coal bound for Scunthorpe Steelworks. *Below:* Loadhaul-liveried Class 56 No. 56116 approaches Brocklesby with a train of empties on 21 September 1995 bound for Immingham. The station and station master's house are Grade II listed buildings.

Class 66 No. 66145 is seen from the public footpath alongside the line at Melton Ross on 10 March 2007 with a train of graffiti-daubed wagons with imported coal from Immingham. Coal landed at the Lincolnshire port could be bound for any one of several destinations

The prototype Class 76 (originally EM1) locomotive was built at Doncaster in 1941 and was eventually numbered E26000 and named *Tommy*. A further fifty-seven of the type were built at Gorton Works between 1950 and 1953. They were employed on freight trains from Sheffield and Wath to Guide Bridge and Mottram via the Woodhead route. Whilst maintained at Reddish MPD several of the class would normally be stabled at Wath over the weekend, which is where Nos 76035 and 76038 were photographed on 1 September 1979. It is noticeable how high the pantographs were extended on these locos.

Class 56 No. 56011 was photographed at Shireoaks on 25 March 1985 with a train of loaded MGR wagons. It would next have passed through Worksop on its journey to either Cottam or West Burton power stations. It could have originated from any one of half a dozen or more South Yorkshire collieries which were still producing coal at the time.

Worksop was a collection point for coal trains before they continued on to Cottam or West Burton. Trains could arrive from several directions including the Shirebrook/Mansfield line, which fed in at Shireoaks East Junction. Opened in 1849 by the Sheffield & Lincolnshire Junction Railway, Worksop station was built in the Jacobean style and is now a listed building. On 10 April 1997 Class 58 No. 58046 *Thoresby Colliery*, one of only thirteen of the type that were painted in Mainline Aircraft blue, is seen heading east to one of the two power stations.

Above and below: The reception/despatch sidings were situated on the north side of the line and to the west of the station. There were also sidings on the south side that were used to store rakes of out-of-service MGR wagons and stable locomotives at weekends. Repairs to wagons were also carried out at this location as evidenced by the wagon wheels in the picture below. When these two pictures were recorded in 1997 the Worksop area was still controlled by mechanical semaphore signals. Within twelve months the signals had been swept away and the signal boxes closed. In the above picture Class 58 No. 58019 *Shirebrook Colliery* is returning from the power station with a rake of empty wagons whilst below No. 58029 is heading east with another trainload of coal on the constant conveyor belt to feed the power stations. Cottam Power Station was commissioned in 1968 and ceased generating on 30 September 2019 whilst West Burton was still functioning in 2021 and was one of the last coal-fired power stations in the UK, albeit reliant on imported coal.

Heading east from Worksop the next significant area of population is Retford where the line to Gainsborough and Grimsby/Cleethorpes dives under the ECML (previously the London North Eastern Railway). The dive-under was constructed in 1963–65 at a cost of around £1 million and replaced a flat diamond cross-over. There was also a connecting curve between the two main lines (seen in the lower picture where they join the Worksop line). Retford Station was rebuilt on two levels. *Above:* Photographed from West Carr Road overbridge, Class 56 No. 56003 is seen heading west with a train of empty MGRs. *Right:* The next westerly vantage point is Ordsall Road, which crosses over two sets of tracks, one above the other. Class 58 No. 58031 *Cabeliero Ferroviano* is seen at this location with a loaded eastbound train.

Two views looking west towards Welbeck Colliery Junction from Peafield Lane overbridge, recorded on 23 April 1991. In the distance, on the left, was the junction signal box and the lines were still protected by semaphore signals. The signal box was opened in July 1915 and closed on 20 December 1997, whilst the rail-served pit closed in May 2010. *Above:* Class 20s Nos 20078 and 20163 are seen heading east towards one of any number of collieries with a rake of empty HEA wagons. *Below:* Meanwhile Class 58 No. 58041 *Ratcliffe Power Station* has brought a loaded train of coal out of Welbeck Colliery; the engine has run round its train before departing in the direction of Shirebrook. In the opposite direction the line continued east to High Marnham Power Station, which ceased functioning in 2003.

On the same day Class 56 No. 56027 is seen at Clipstone heading for one of the collieries with a train of empty MGR wagons. No. 56027 was withdrawn in September 2008 and cut up by Booth's of Rotherham the following year. The last two Nottinghamshire collieries in the Clipstone area, Mansfield and Thoresby, both closed in 2015.

Staveley Barrow Hill Sidings was an arrival/departure point for MGR trains to/from a wide variety of destinations, both near and far. Class 56 No. 56081 was photographed departing the sidings on 3 April 1991 with a northbound train of empties, whilst in the distance another of the type waits to follow it. The line from Seymour and Oxcroft curves in on the left (the extensive Stanton & Staveley pipe manufacturing ironworks also used to occupy a site on the left). Barrow Hill engine shed is out of sight on the right with the access track joining the main line opposite the distant locomotive.

Class 58 No. 58047 *Manton Colliery* is seen at Hall Lane Junction, on the Seymour branch, on 3 April 1991 with a train of empty wagons heading towards Barrow Hill. On the right used to stand the sprawling Devonshire Iron and Chemical Works. Latterly owned by the British Steel Corporation the site was progressively cleared from 1980 onwards. All trace of this section of railway has since been removed.

Seymour Sidings were latterly used as a collection point for coal trains from Markham and Bolsover collieries (both of which closed within a couple of months of each other in 1993) and Oxcroft opencast site. Class 58 No. 58043 *Knottingley* is seen on 5 June 1991 climbing the grade away from the sidings, having come off the Bolsover/Markham colliery branch with a loaded train. The site closed in 2006 following the closure of Oxcroft and all evidence of the rail facility has since been erased from the landscape.

Staveley Barrow Hill engine shed was built by the Midland Railway and opened in November 1870. The main structure consisted of a square roundhouse containing twenty-four stabling roads grouped round a single turntable. It was closed to steam on 4 October 1965 but continued to be used to stable diesel locomotives until its eventual closure on 9 February 1991. The shed has been home to a number of interesting locomotives including Deeley 0-4-0Ts and Johnson Class 1F 0-6-0Ts (for shunting in the nearby ironworks) and a number of Clayton Class 17 centre-cab diesels, which were allocated there from new in November 1964. *Above:* Class 20s Nos 20170/214/084/196 are seen alongside the coaling tower on 20 May 1989. *Below:* Class 58s Nos 58050 *Toton Traction Depot*/33/30 and Class 56 No. 56005 are seen grouped around the turntable on 27 May 1990. The building is now Grade II listed and is a working museum.

Above: Class 20s Nos 20105 and 20064 are seen heading south through Chesterfield station on 28 May 1985 with a short rake of HEA coal hoppers. Their most likely point of origin would be one of the trio of mines on the Seymour Sidings branch, from Staveley Barrow Hill, namely Bolsover and Markham Collieries and Oxcroft Opencast Mine. *Below:* Heading in the opposite direction on the same day was Class 56 No. 56071 with a train of empty MGRs bound for Barrow Hill. No. 56071 entered service in December 1979 and remained in use until November 2006. It was still in store in 2020.

Above and below: Two empty coal trains are seen north of Chesterfield station on 16 February 1994. It is likely they are heading for Staveley Barrow Hill Exchange Sidings, although their places of origin are unknown. Both locomotives, Class 60 No. 60066 *John Logie Baird* and Class 58 No. 58004, carry the coal sub-sector branding, which was introduced with the concept of sectorisation in 1987. The other sub-sectors comprised Construction, Metals, Petroleum, Railfreight Distribution and Railfreight General. In 1994 these were rationalised into three sectors, namely Transrail Freight Ltd, Mainline Freight Ltd and Loadhaul Ltd, which paved the way for privatisation. In the lower picture the famous 228-feet-high crooked spire of St Mary and All Saints Church can be seen on the right. The church dates from *c.* 1360.

Two views recorded from a public footpath overbridge at Hasland, just south of Chesterfield. *Above:* On 9 March 1995 Class 58 No. 58010 *Audrey Newton* was hurrying south with a loaded train of MGR wagons. The most likely point of origin would be Seymour Sidings near Staveley Barrow Hill but its destination could be one of several power stations. *Below:* Class 60 No. 60079 *Foinaven* was photographed heading north on 10 July 1996 with a consist of empty MGRs. It is passing Avenue Coking Works, which was closed down in 1992. Alleged to be one of the most polluted sites in Europe, the Washlands Nature Reserve was created on this site between 2005 and 2008. On the opposite side of the line, now completely overgrown in this view, used to stand Hasland steam locomotive shed (code 18C), which was closed in September 1964. The shed was one of only three that had an allocation of 2-6-0 + 0-6-2T ex-LMS Beyer-Garratts, with the last one being withdrawn in 1957.

Just a few miles south of Hasland is Clay Cross Junction where the Erewash Valley line to Toton and Long Eaton diverges from the line to Derby and Burton-upon-Trent. *Above:* Class 58 No. 58035 was photographed on 23 August 1991 coming off the Erewash Valley line with a train of empty MGR wagons, which is possibly bound for Staveley Exchange Sidings. In the background is the sprawling Clay Cross Coal and Iron Works, which was founded in 1837 by George Stephenson and closed in 1998 following the takeover by Stanton. All trace of the works has since been removed from the landscape. *Below:* Travelling in the opposite direction on 11 May 1994 was Class 56 No. 56093 *The Institute of Mining Engineers*. The train could be working from Oxcroft Opencast Mine via Staveley to Willington Power Station.

Shirebrook MPD was a modern diesel servicing facility that was located in close proximity to the South Yorkshire coalfields and was opened in June 1965, with the nearby Langwith Junction steam shed closing a few months later. Locomotives based there over the years were Class 08s, 37s, 47s, 56s and 58s and were drawn from the ranks of both Tinsley and Toton Heavy Maintenance Depots. Probably the depot's most notable occupant was Brush Traction's prototype 4,000-hp Sulzer-engined No. HS4000, also known as *Kestrel*, which was trialled on heavy coal trains in the region in 1968. Tinsley's allocation of Romanian-built Class 56s were a common sight at the depot from their introduction in 1976 until closure of Shirebrook in 1996. *Above:* Romanian Class 56 examples Nos 56026 and 56027 are seen coming off shed on 28 May 1985 with the remains of the platforms of Shirebrook South station evident in the foreground. *Below:* Class 58s No. 58017 *Eastleigh Depot*, No. 58046 *Thoresby Colliery* and Class 56 No. 56007 are seen at rest on Saturday 24 March 1990.

Class 58 No. 58012 is seen at Whitwell on 30 September 1992 on what at the time was the freight-only line from Worksop to Nottingham via Mansfield and Kirkby-in-Ashfield. In the distance was the site of the original Whitwell station, which was closed in October 1964. The signal box was closed on 4 May 1997 and the line has since been reopened to passenger traffic and a new Whitwell station has been built on the original site, which was opened in 1998. The train would have been heading for one of the Nottinghamshire collieries.

At one time this section of the old Midland Railway through Duffield consisted of four tracks. What used to be the Up Slow (on the left) is now known as Donald Hawley Way. Viewed from the highway vantage point on 7 July 1990 was Class 58 No. 58039 *Rugeley Power Station* with a northbound train of empties, possibly from Willington PS.

Two empty MGR trains are seen passing at Willington, south of Derby, on 17 August 1992. Class 60 No. 60097 *Pillar* is heading north whilst Class 58 No. 58008 is on a southbound train. On the left (just out of sight) is Willington Power Station (closed in 1999) whilst in the distance is North Stafford junction where the line to Stoke-on-Trent and Crewe branches off.

Westhouses steam shed was situated at Tibshelf in Derbyshire and was opened by the Midland Railway in 1890; the last steam locos vacated the site in October 1966 but it continued to be used for stabling diesel locomotives, particularly Class 20s, 25s, 47s and 56s, until 1987. This view dates from 21 November 1981 by which time most of the original shed building had been demolished. All trace of this site has since been erased.

Continuing south from Clay Cross along the Erewash Valley line, the next town of any significance is Alfreton. On 10 July 1989 Class 58 No. 58036 is seen heading south with a train of loaded MGR wagons, destination unknown.

Seen further south on the same day at Langley Mill are Class 20s Nos 20215 and 20108 with another rake of southbound MGR wagons. The leading locomotive was delivered new to British Railways in May 1967 and was withdrawn in March 1992 whilst the trailing engine almost completed thirty years in service, having been turned out from Robert Stephenson & Hawthorn's Darlington Works in December 1961.

Bennerley coal disposal point was used to process coal from adjoining opencast sites. It was located on the Erewash Valley line between Langley Mill and Long Eaton (Toton) and was accessed off a truncated branch that used to lead to Watnall (station closed in 1917). *Above:* Class 56 No. 56010 is seen coming off the branch with a loaded train, possibly bound for Ratcliffe Power Station. With the downturn in coal traffic the site was closed in the 1990s and the four-track main line has since been reduced to two tracks. *Below:* Another Romanian-built example, No. 56003, is seen heading north at Bennerley with a train of empty MGR wagons, which is probably bound for Staveley Barrow Hill or Seymour Sidings. On the hill, on the left, it is just possible to discern a ski run. Both photographs were recorded on 30 September 1992.

Two more views recorded on 30 September 1992, looking towards Bennerley Viaduct from both directions. The sixteen-arch wrought-iron viaduct was built in 1876–77 and carried the Great Northern Railway over the Midland line. It survived the closure of the line in 1968 and is now a listed structure. *Above:* Class 56 No. 56019 is in charge of a load of South Yorkshire coal as it heads south towards Toton. *Below:* Seen heading north is Class 58 No. 58008 with a rake of empty wagons. Introduced in 1983, the fifty-strong class of 58s was almost exclusively employed on coal trains in the Midlands and South Yorkshire at the time. However, in later years they had a short spell working in North Yorkshire from Knottingley depot before being used more widely throughout the network on a variety of trains. They were all withdrawn between 1999 and 2002 and some subsequently saw service in France, the Netherlands and Spain.

Two views recorded at the north end of Toton Marshalling Yard. This was the site of Stapleford & Sandiacre station, which was closed to passengers on 2 January 1967; the footprint of the location of the former platforms is clearly discernible. *Above:* A busy scene recorded on 24 March 1993 sees smokey Class 56 No. 56005 departing north with a train of empty MGR wagons whilst Class 08 No. 08773 shunts another rake of MGRs. Toton Diesel Depot is just out of sight under the road bridge (A52) whilst the cooling towers of Ratcliffe-upon-Soar Power Station are visible above the bridge. *Below:* Coal Sector-branded Class 60 No. 60091 *An Teallach* (a Scottish mountain) is seen on the same date departing from the east-side sidings with another train of empty MGR wagons.

Looking north from Station Road overbridge at Stapleford, Class 58 No. 58013 was photographed on 21 March 1997 with a southbound train of coal. This could be a short working to nearby Ratcliffe or it could be going further afield. The spaced out tracks are a reminder that the platforms of Stapleford and Sandiacre station had previously occupied the two spaces.

Toton diesel depot was opened in 1963 and was built adjacent to the north steam shed, which closed soon afterwards. The south steam shed wasn't closed until December 1965. The initial allocation consisted of Class 08s, 20s, 25s, 27s, 31s, 44s, 45s and 47s. It later received an allocation of Class 56s followed by the entire classes of 58s, 60s and EWS 66s. The six former National Power Class 59s were later transferred to Toton. On 27 May 1990 Class 58 No. 58023 *Peterborough Depot*, Class 20 No. 20114 and Class 37 No. 37250 were to be seen in the yard.

Also on 27 May 1990 Class 58 No. 58019 *Shirebrook Colliery* is seen inside the depot, having been raised on hydraulic jacks and the bogies removed for inspection. The Midland Region code for Toton was 18A, which was changed to 16A in 1963. In 1965 the depot was placed in the Nottingham Division, which initially assumed the code M16 before being changed to D16. The current code of 'TO' was allotted to the depot in 1973.

Toton depot has long been associated with lines of withdrawn locomotives. As the depot received numbers of Class 60s in the early 1990s, so these replaced pairs of Class 20s on coal train duties. On 24 March 1993 Nos 20151/210/071/140/019 were amongst redundant members of the class that greeted the visitor at the entrance to the depot.

Coal from the Derbyshire and Nottinghamshire coalfields was often staged at Toton before being despatched to a host of different power stations. These included Cottam, Didcot, Drakelow, High Marnham, Ratcliffe, Rugeley and West Burton. Several of the mines closed in the 1990s whilst Welbeck and Thoresby lasted until 2010 and 2014 respectively. By the latter date Toton Yard's raisin d'être had all but been reduced to nought. In 2020 several of the remaining sidings were used for the storage of redundant locomotives whilst it has been mooted that a new station on a high speed rail link could be built on the site in the foreseeable future. *Above:* Class 56 No. 56090 is seen departing with a loaded coal train for nearby Ratcliffe-on-Soar Power Station on 13 March 1985; the wagon repair works are still extant in the background. *Below:* On the same date Class 58 No. 58008 was photographed from the same footbridge vantage point arriving with a train of empty MGRs. The gas holder has since been demolished.

Toton Marshalling Yards were established by the Midland Railway in the late nineteenth century, primarily to process the vast amount of coal traffic from the Nottinghamshire and Yorkshire coalfields for onward shipment to the industrial Midlands. At one time the site was the biggest of its type in Europe. By the 1980s it had been reduced to a shadow of its former self. On 23 July 1985 Class 20s Nos 20094 and 20080 were photographed at the south end of the yard with a train of HEA wagons heading towards Nottingham.

Class 58 No. 58026 is seen arriving at Toton on 14 August 1991 with an empty rake of MGR wagons. The bridge used to carry the line from Nottingham but the track has since been taken up. No. 58026 was reported to be in store at the Rouen Alizay Depot in France in 2020. The cooling towers of Ratcliffe Power Station can just be seen above the rear cab of the locomotive. Also the cylindrical tanks have since been removed and that site is now occupied by a large supermarket.

Class 60 No. 60016 (later renumbered to No. 60500) *Langdale Pikes* is seen arriving at Toton Exchange Sidings on 29 August 1998 (point of origin unknown). To the right is the main Erewash Valley line whilst the Class 60 could have come from the Nottingham direction or the loop that leads onto the Erewash line and to Ratcliffe Power Station.

The wagons behind seven months old Class 58 No. 58024 cast a uniform shadow pattern over the ballast as it proceeds south at Long Eaton on 23 July 1985 with a loaded train of coal. Toton yard is just beyond the bridge in the background whilst a lone semaphore signal can be seen on the extreme left.

When Ratcliffe-on-Soar Power Station was first commissioned in 1968 it was said to be consuming almost thirty trains of coal every twenty-four hours. Over the years it has taken its coal supply from a variety of sources including Scotland and through a number of UK ports. On 18 March 1992 Class 60 No. 60082 *Marn Tor* was photographed passing the thirsty monolith with a train of southbound empties. It was one of the few still functioning in 2021.

This idyllic rural scene was recorded from Haselour Lane Bridge near Harlaston, which is between Burton-on-Trent and Tamworth, on 8 April 2014. It depicts Freightliner's low emission Class 66 No. 66957 *Stephenson Locomotive Society 1909–2009* with a train of loaded bogie MGR wagons. It is possibly conveying coal from Immingham to Rugeley Power Station.

Class 58 No. 58019 *Shirebrook Colliery* is seen on the four-track main line just north of Loughborough on 3 April 1991 with a train of mainly hooded MGR wagons heading for Didcot Power Station, which will see it travel via Nuneaton, Tyseley, Leamington Spa, Banbury and Oxford.

Class 58 No. 58022 is seen on the WCML at Mill Meece, just north of Stafford, with a train of coal from Silverdale Colliery to either Rugeley or Ironbridge power stations on 19 March 1998. This was the last year of production of coal at the mine. The chimney of the village Pumping Station is prominent in the background. Opened in 1915, it was powered by two steam engines until 1979. No. 58022 was withdrawn in March 2002 and was resident at the Ecclesbourne Valley Railway in 2021.

The high level line at Tamworth carried a significant amount of freight traffic including coal trains. Class 66 No. 66035 is seen heading towards Birmingham on 2 May 2007. No. 66035 was repainted into DB Cargo UK livery and named *Resourceful* in February 2018.

During the 2000s Rugeley Power Station received imported coal through a variety of ports including Hull and Immingham on the east coast. Some trains ran direct from the ports and others were staged at Barrow Hill. The route taken could be via Burton and Tamworth or via Leicester and Nuneaton to Bescot and then on to Rugeley PS, which was accessed off the line from Walsall. Freightliner Class 66 No. 66547 is seen at Nuneaton on 23 November 2009 with a return empty working.

Didcot was another thirsty power station and commanded a constant procession of coal-laden trains to keep it generating, as this next sequence of pictures testifies. Coal-sector Class 60 No. 60069 *Humphry Davy* (renamed *Slioch* in May 2004) was photographed at Barton-under-Needwood on 1 July 1993. Central Rivers TMD was opened behind the photographer's vantage point in September 2001.

A few miles further south and Class 60 No. 60091 *An Teallach* was recorded at Kingsbury, on 24 March 1993, with a train bound for Didcot. The picture was taken from Piccadilly Way overbridge. No. 60091 was renamed *Barry Needham* (Great Heck rail accident victim) in June 2014 and was repainted into DB Schenker UK cherry red. It was still in service in 2021.

Saltley engine shed was opened by the Midland Railway in 1868 and was closed to steam in March 1967. It latterly consisted of three roundhouses. These were demolished and replaced by a three-road diesel inspection and refuelling shed and other assorted makeshift buildings. It continued in use for stabling diesel locomotives until 2006 but remained as a signing-on point in 2020. Seen on 27 May 1989 are Class 58s Nos 58009/017 *Eastleigh Depot*/007 *Drakelow Power Station*/011 *Worksop Depot*/005 *Ironbridge Power Station*. The site is now occupied by industrial units.

Class 58 No. 58018 was photographed at Saltley on 27 May 1989 heading back to Nottinghamshire or South Yorkshire with a consist of empty MGR wagons from Didcot Power Station. In the distance the line curves round the back of Birmingham City's St Andrew's Football Stadium (known as the Trillion Trophy Stadium in 2021) before joining the line through Tyseley and then Acocks Green.

Above and below: As the avoiding line from Saltley joins the line from Birmingham New Street, it passes through the district of Small Heath. Photographed from the vantage point of Golden Hillock Road on 24 March 1993 were Class 60s No. 60075 *Liathach* (above) and No. 60092 *Reginald Munns* (below). Both are in charge of loaded coal trains bound for Didcot Power Station. At the time this was one of the longest hauls for any MGR trains in the UK, the distance from Barrow Hill (where some of the trains originated) being 143 miles. Similar or greater distances were later achieved with the transportation of imported coal from Hunterston in Scotland. The Birmingham city skyline stands out against the grey clouds with the BT Tower, bristling with satellite dishes, prominent as the tallest building on view, standing at 499 feet tall.

At the end of 1989 there was still seventy-three National Coal Board mines producing coal and the tonnages of imported coal were somewhat insignificant. Virtually all of the coal-fired power stations were still taking British coal in large quantities. As previously stated one of the longest hauls at the time was to Didcot Power Station, which sourced a lot of its coal supply requirements from the East Midlands. *Above:* On 17 May 1989 Class 56 No. 56011 was photographed on the centre road at Leamington Spa with a loaded train bound for Didcot. *Below:* Just three weeks later Class 58 No. 58031 was recorded at the same location with another loaded rake of MGRs. As the Class 60s entered service from the early 1990s these became the preferred motive power for these long-distance trains.

Another view at Leamington Spa on 6 June 1989 sees Class 58 No. 58024 with a train of empty MGRs bound for the Midlands. The large logo livery with red solebar and large cab numbers particularly suited the 'Bones' as they were referred to by some railway enthusiasts. The station was opened by the Great Western Railway in 1852 and is now a Grade II listed building.

Class 37 No. 37131 (delivered new to Cardiff Canton MPD as No. D6831 in March 1963) is nearing journey's end on 17 May 1989 with its loaded mixed rake of HEA and HAA coal wagons. It would have been going no further than Hinksey yard just to the south of Oxford station. The coal may have been bound for the Becket Street coal depot. No. 37131 remained in service until June 2005 and was cut up at Booth's Rotherham yard two years later.

Class 60 No. 60075 *Liathach* is seen at the same location on 1 September 1993 with a trainload of Derbyshire-mined coal bound for Didcot Power Station. In the 1980s and early 1990s as many as seventeen trains a day made the long journey south and when Didcot switched to burning imported coal in 1994 this had a profound effect on mining in the East Midlands and contributed to the acceleration of the demise of the coalfields in that part of the country.

There were two power stations at Didcot known as 'A' and 'B'. Didcot A was commissioned in 1970 and decommissioned in 2013 whilst Didcot B commenced operation in 1997. The latter used four open cycle gas turbines, which were fired by gas-oil. Coal supplies, most of which latterly came from South Wales or through the Bristol Port of Avonmouth, ended in 2013 when Didcot A ceased generating. Class 60 No. 60099 *Ben More Assynt* had completed the discharge of its wagons when photographed on 9 September 1998.

Class 37 No. 37223 is seen at Westbury on 20 March 1991. The train of HEAs would have been delivering coal to the nearby Blue Circle Cement Works, the origin of which is likely to have been Radyr near Cardiff, although at the time the works also received coal from Rufford Colliery in far away Nottinghamshire.

In 2002 part of the Portishead branch was reopened as far as Portbury, thereby restoring rail access to the Royal Portbury Docks. The principal imports through the docks were aviation fuel, coal and motor vehicles. At the time Class 66 No. 66527 was photographed at Bristol Temple Meads on 16 March 2013, Freightliner had regular flows of coal from Portbury to Didcot, Fiddlers Ferry, Ironbridge and Rugeley power stations.

For over a century the South Wales coal mines were a hive of activity. In 1880 there were 277 working mines listed in Glamorgan alone. By the 1980s these had dwindled to small numbers. Class 37/5 No. 37698 *Coedbach* is seen at Tondu Middle Junction on 28 April 1989 removing a defective wagon from its Maesteg Washery to Cardiff Tidal Sidings' train. The Washery closed a few months later. The line to the right led to Blaengarw Ocean and Ogmore Vale Caedu Collieries, both of which closed in the mid-1980s. The signal box was opened in 1884 and was still functioning in 2021. (Geoff Cann)

When Newport Ebbw Junction diesel depot was closed in the mid-1980s a signing-on and stabling point was established at Godfrey Road, at the west end of the station. It was normally frequented by Class 37s and Class 56s and then from the late 1990s by Class 66s, which were used on a variety of duties including coal trains to Llanwern Steelworks. Visible from the platform on 28 May 2001 were Class 66s Nos 66120, 66203 and 66184.

Llanwern Steelworks, located a short distance to the east of Newport station, was opened in 1962 and at one time was the British Steel Corporation's leading hot strip mill. It required a regular supply of coal, which came from various sources within South Wales. The Class 37/7 sub-class comprised locos renumbered to 37701–19, 37796–803 and 37883–99, which had been re-engineered to handle heavy freight trains such as coal and steel traffic. *Above:* Class 37 No. 37898 (originally D6886 and first allocated to Landore in November 1963) is seen passing through Newport station on 25 July 1990 with a train of empty MGRs, possibly bound for Swansea Burrows Sidings or Port Talbot Grange Sidings. *Below:* Ten years later and the Class 66s were coming on stream to replace the Class 37s. No 66027 is seen at the same location on 25 June 1999 with a train bound for Port Talbot.

The four-track main line between Newport and Cardiff is the main freight artery connecting South Wales with the rest of the UK. Principal traffic flows included coal, containers, scrap metal and steel. Loaded coal trains would generally be bound for Llanwern Steelworks or Uskmouth Power Station at Newport, although some trains of Welsh coal did travel further afield. Two eastbound empty trains are depicted here. *Above:* Class 37 No. 37899 *Sir Gorllewin Morgannwg/County of West Glamorgan* is seen near the village of Peterstone on 31 July 1992. *Below:* Class 56 No. 56038 *Western Mail* is seen on the outskirts of Newport on 19 May 1998 heading for Port Talbot Grange Sidings.

Two scenes recorded at Pengam on the eastern outskirts of Cardiff on 21 April 1993. *Above:* Class 37 No. 37800 *Glo Cymru* is in charge of seven loaded MGR wagons, which have originated at the nearby Ryan's coal terminal in Cardiff Docks The branch also led to Tidal Sidings and the Allied Steel & Wire Terminal. The main line, looking towards Cardiff, is on the right. *Below:* Another of the same 37/7 sub-class, No. 37801, is seen approaching from the Newport direction with a train of empty MGR wagons. Pengam Freightliner Terminal is situated on the right whilst five loaded MGR wagons from the docks are waiting to be picked up. Three hundred and nine Class 37s were built at Vulcan Foundry and Robert Stephenson & Hawthorns between 1959 and 1964, of which nearly a third were allocated new to the South Wales MPDs of Cardiff and Landore. Sixty-seven of the type were still in use nationwide in 2020, with No. 37800 being part of the Europheonix stable of nine.

Class 47 No. 47326 was photographed at Pengam on 21 April 1993 with a mixture of coal carrying wagons in tow. Besides the HEAs and HAAs there is a single box wagon in the consist. These wagons have probably come from one of the two wagon repair centres in the Cardiff area, namely Barry and Maindy at Radyr.

For several decades trainloads of Welsh coal were hauled by GWR tank engines and later Class 37s from the valleys' mines to Barry Docks for export. This all ceased in 1976 and several years later the role was reversed with the docks receiving imported coal. Class 37s Nos 37703 and 37898 *Cwmbargoed DP* were photographed at Eastbrook, between Barry and Cardiff, with loaded MGRs bound for Aberthaw Power Station (closed in 2020) on 27 April 1993.

Class 66 No. 66184 is seen passing the backs of the terraced houses in Ninian Park Road in Cardiff on 30 June 2000. Out of sight on the left is the Cardiff Canton diesel depot, which was closed by EWS in December 2005. No. 66184 is in charge of another train of Welsh coal from West Glamorgan to Llanwern Steelworks.

Ironbridge Power Station, which was situated on the line from Shrewsbury to Wolverhampton, received imported coal from a number of ports, which included Bristol's Portbury Docks. To avoid travelling through Birmingham the trains were routed via Newport, Hereford and Shrewsbury to Wolverhampton (reverse) and then back to Ironbridge. On 21 May 2011 Class 70 No. 70010 has stopped on the curve behind Severn Tunnel Junction signal box at Shrewsbury to change crews. Freightliner's Class 70s employed on these trains worked off Stoke Gifford depot.

Coal for domestic use was also conveyed to what were known as coal concentration depots. The trains would usually be of a short consist of HEA coal wagons, which had the same capacity as the HAAs. However, they had to be unloaded manually, which usually entailed the wagons being left at the depots for a number of days. So the locomotive would arrive with a set of loaded wagons and depart with a train of empties. By the mid-1990s this practice had almost completely ceased. *Above:* Class 37 No. 37797 is seen passing Shrewsbury's magnificent Severn Bridge Junction signal box on 1 July 1993 with a train of empties from Preston's Deepdale Depot to Barry Docks. The signal box was built by the LNWR and opened in 1904 and was equipped with a 180-lever frame. *Below:* A similar train is seen at Reading on 1 September 1993 returning from the depot at West Drayton behind split-headcode box Class 37 No. 37038.